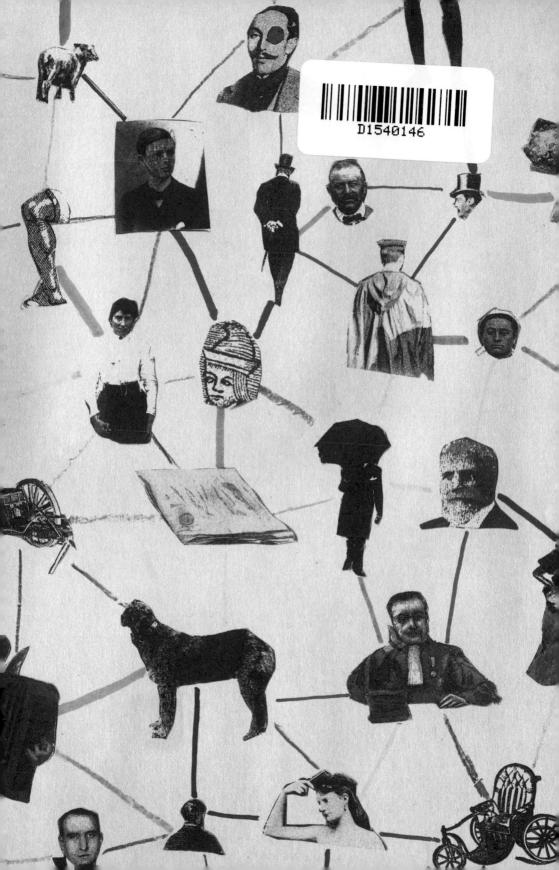

for my mom and dad

Illustrated Three-Line Novels: Félix Fénéon
© 2010 Joanna Neborsky

English translation © Luc Sante from *Novels in Three Lines*, courtesy of New York Review Books.

Edited by Buzz Poole

Every effort has been made to trace accurate ownership of copyrighted text and visual materials used in this book. Errors or omissions will be corrected in subsequent editions, provided notification is sent to the publisher.

Library of Congress Control # 2009939177

Printed and bound by Asia Pacific Offset, China

10 9 8 7 6 5 4 3 2 1 First edition

This edition © 2010
Mark Batty Publisher
36 West 37th Street
Suite 409
New York, NY 10018

www.markbattypublisher.com

ISBN-13: 978-0-9841906-6-9

Distributed outside North America by:
Thames & Hudson Ltd
181A High Holborn
London WC1V 7QX
United Kingdom
Tel: 00 44 20 7845 5000
Fax: 00 44 20 7845 5055
www.thameshudson.co.uk

ILLUSTRATED

Three · Line Novels:

Félix Fénéon

BY JOANNA NEBORSKY

TRANSLATED BY LUC SANTE

ACKNOWLEDGMENTS

I am grateful to Luc Sante, who told me what the Frenchman said. Thanks to editor BUZZ POOLE, who did me the kindness of first liking this project, and designer Christopher Salyers, who gave the book its pretty shape. Sara Kramer at NEW YORK REVIEW BOOKS CLASSICS was a gracious liaison, and MAIRA KALMAN, as my advisor at the SCHOOL OF VISUAL ARTS told me to stop foolin' and illustrate the scene; a book emerged. Three vivas for ANDRÉ DA LOBA, reluctant art director and forgiving studio mate. CAOLAN MADDEN buffed the introduction, JESSICA DIMSON commiserated, MOLLY KLEIMAN cheered. Grandparents STANLEY and FLORINE STEINBACH had the 'gall' to love Gaul — and a penchant for (terrible) punning. I borrow from them. FRIENDS, family, BAND: May you never be arrested as a seminude NAPOLEON IV-impostor at the Trianon Palace. It isn't worth it!

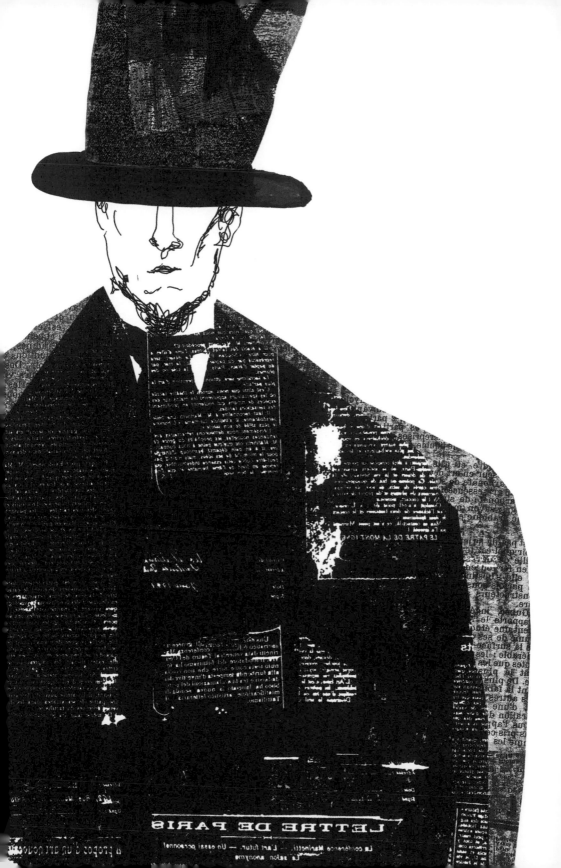

INTRODUCTION

Mme Fournier, M Vouin, M Septeuil of Sucy, Tripleval, Septeuil, hanged themselves: neurasthenia, cancer, unemployment.

So what if the news was bad in 1906? Humanity has always lusted, thieved, murdered, fallen under scavenger carts, and died. But not every age has had a master stylist to condense the missteps of our species into mercilessly unsentimental epigrams:

A dishwasher from Nancy, Vital Frérotte, who had just come back from Lourdes cured forever of tuberculosis, died Sunday by mistake.

I have spent the last year elbow-deep in the newsprint and gore of Félix Fénéon's antique news briefs, severing bowler-hatted heads from ascots and vested bodies from pantaloons in fields of torn Xerox and construction paper. A gruesome business, collage. The form lends itself to depicting unlucky ends, which is good news for the collagist illustrating Fénéon, if not such good news for Bonnaut (stabbed by a gangster named Shoe Face, Montreuil), Mme Lesbos (run over by a tourist omnibus, Versailles), and Inghels (pile of logs, Quai d'Austerlitz). The true short stories of Félix Fénéon, in which people die ignoble, comic, half-forgotten deaths, confirm that we are each hurtling toward unseen disaster. The thousand of them attest, like collage itself, to the absurd miscellany of life.

A certain laborer of Montmartre named Fraire but called Cruddy, died of amazement, a newly made heir, in the office of a notary, Seine-et-Oise.

Félix Fénéon was a dandy, a literary bricoleur, and a terrorist, maybe. Biographers dispute his guilt in the 1894 bombing of a restaurant in Paris. As the journalist himself might later have written, "A flowerpot left on a windowsill exploded in the Rue de Conde. In the Restaurant Foyot, appetites and the eye of Laurent Tailhade, 40, were lost." Fénéon, then a clerk in the government's War Office, was arrested and tried in the sensational Trial of the Thirty, a piece of political theater aimed at exposing the anarchist underground. After he was acquitted (evidence was flimsy, the prosecution inept), two policemen followed Fénéon for the next two decades. But how do you shadow a shadow? In life and work, the wraithlike Fénéon—his lean face darkened by a top hat and limned by a goatee that friends said gave him the look of Uncle Sam, or Mephistopheles—preferred to disappear. His love was art, and his subject, the genius of others. At the turn of the last century, Fénéon nurtured the reputations of Seurat, Mallarmé, Toulouse-Lautrec, Jarry, and Gide; he named neo-impressionism, compiled Rimbaud's *Illuminations*, and published Joyce. Years passed, and his already-dim presence began to fade from readers' minds. He died in 1944.

It might have amused the prolific critic and editor that his work destined to find the most modern readers was the gloomy newspaper column he filed anonymously at a Paris newspaper for seven months. From May to November of 1906, Fénéon wrote 1,220 short, spry news items for *Le Matin* (his was the night shift). Culled from newswires across France, letters,

and even telephone calls, the column of *faits-divers* reported incidents grisly and mundane: farm accidents, saloon dramas, church burglaries, scientific adventures, labor strikes, suicides, obscure lives abridged by pistol shots and trains. Among those who blundered into Fénéon's dramas were accountants, burglars, glovers, pipe-makers, urchins, farmers, pious ladies, jealous husbands, priests, soldiers, sailors, and politicians. Everyone, more or less. And everyone, more or less, was reading all about it. When Fénéon's tales made their first smudgy appearance in print, they were intended to enthrall readers of the new tabloid press, which was illustrated, lurid, violent, and cheap. It was a time of multiplying novelties, low, dispensable entertainments, and mass audiences: people crowded around toppled carriages, kiosks hawking *Le Petit Journal*, and marvels at the World's Fair. France advanced in optics, ballooning, telegraphy; the Lumière brothers invented cinema, Emile Durkheim sociology, and street vendors the ice cream cone. Feneon's *nouvelles* date to an era that was busy about the future; indeed, in their sharp, modernist, fragmented way, they did their part to herald that future.

How did they survive? Not without some treachery against their author, who had told a publisher interested in preserving the *nouvelles*, "I aspire only to silence." Fénéon's mistress clipped his columns in a secret album, undiscovered until the 1940s, and in 2007, Luc Sante, the Belgian-American writer, translated them for New York Review Books Classics. To the chronicle of literary rediscoveries of Félix Fénéon, I hesitate to add the dull scene of my own: I knelt, in late 2007, on the fourth floor of the Union Square Barnes & Noble, in search of a cheap and amusing birthday present for my friends Caolan and Paul. As a gift for two Anglophiles, Fénéon's *Novels in Three Lines* was all wrong, unless you consider the high incidence of maimed Frenchmen, and the reserve of lines like

A bottle floated by. Maurtiz, of Sèvres, leaned over to grab it and fell into the Seine. He is now in the morgue.

The section was True Crime. I bought three copies.

Three years later, I have illustrated twenty-eight Fénéon miniatures. The three sections of this book begin with science bulletins before descending into less hopeful realms of human achievement, like the man who fenced against a lamppost and lost. In representing the tales, I took inspiration from the curlicued typography of Belle Époque posters, the street scenes of faded postcards, the personal photographs of Colette, Gide, and other fin-de-siècle luminaries. I researched Second Empire safes and 1900 barber kits; I scanned a broken vase. In the vaulted reading room of the New York Public Library on Forty-Second Street, I paged through a nineteenth-century French pamphlet on the future of the sardine industry (and I'm pretty sure I'm the only one who ever felt the need to). I hope I have been true to Fénéon, that these pages, though longer-winded, maintain some glimmer of his skeptical wit. More than a century has passed since the caped, goateed anarchist-aesthete who befriended Seurat before he un-friended Gaugin wrote about men and women squabbling, stumbling, and injuring one another across a blighted, changing France, but I recognize them intimately. Folly endures; tragedy and meaningless specificity, too. Just yesterday I yelled at a security guard as I walked into Lamps Plus; he may have yelled back.

Joanna Neborsky
NEW YORK

1

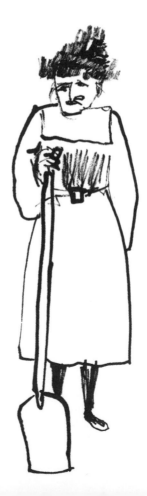

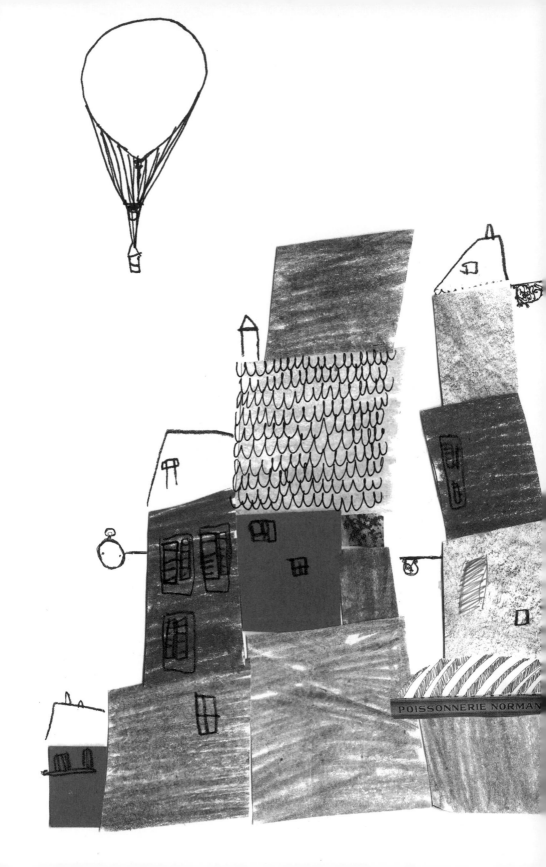

POISSONNERIE NORMAN

In BELFORT,

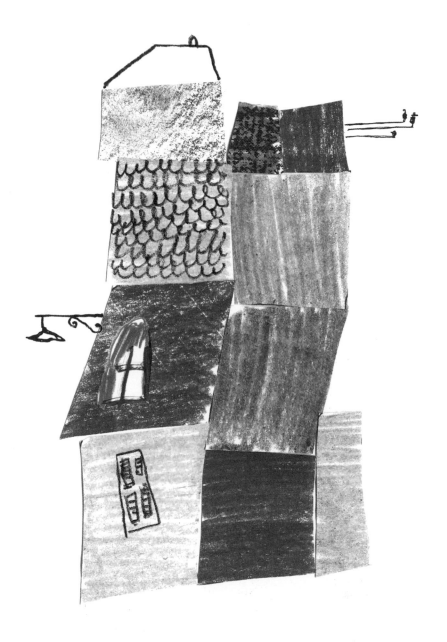

Fig. 2.

signalmen of the **1sT ENGINEERS**, visiting from VERSAILLES, went up in a balloon,

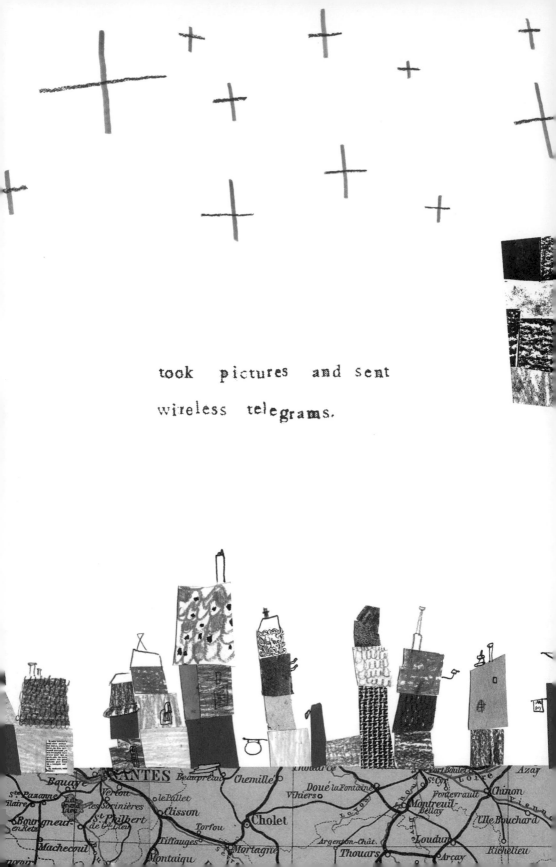

took pictures and sent
wireless telegrams.

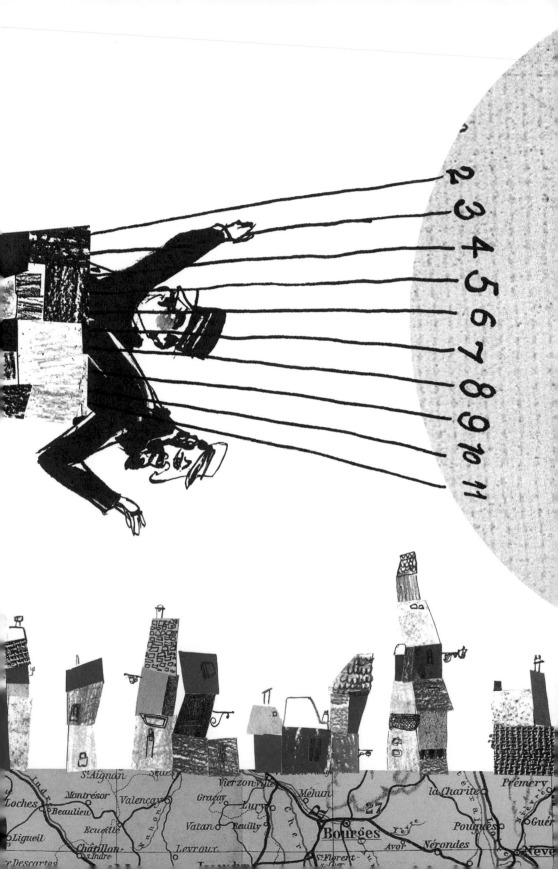

A "ROYAL FISH"

weighing **330** pounds

is on exhibition in

TROUVILLE

for **5** cents.

It has been offered
to the `Paris` zoo,
which has not
responded.

THREE SEALS
82 MONKEYS
20 PARROTS
15 CATS
32 DOGS
63 EXHIBITORS and their
10 CONVEYANCES
were rerouted from VERSAILLES
to SAINT CYR.

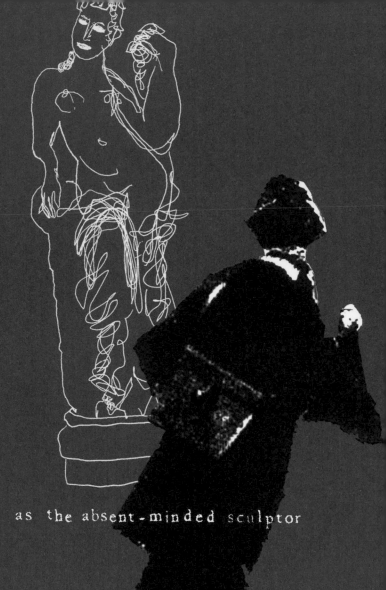

Just as the absent-minded sculptor

BOMBARÈS.

who should've gotten off at

CHAMPIGNY,

leapt from the moving train,

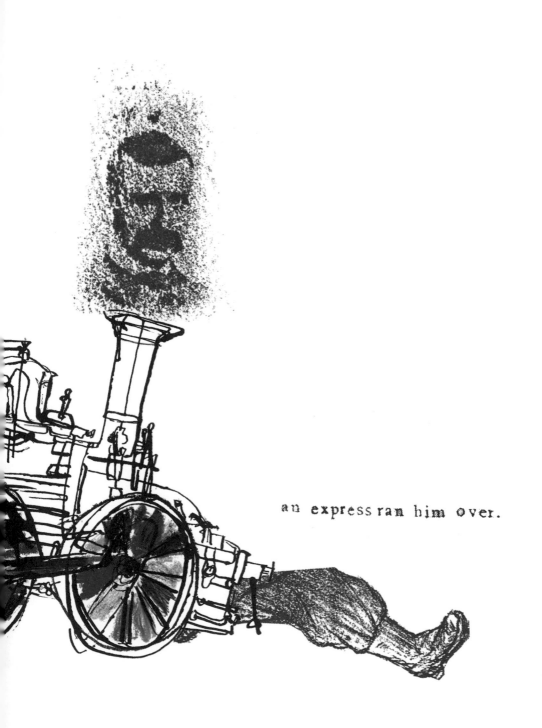

an express ran him over.

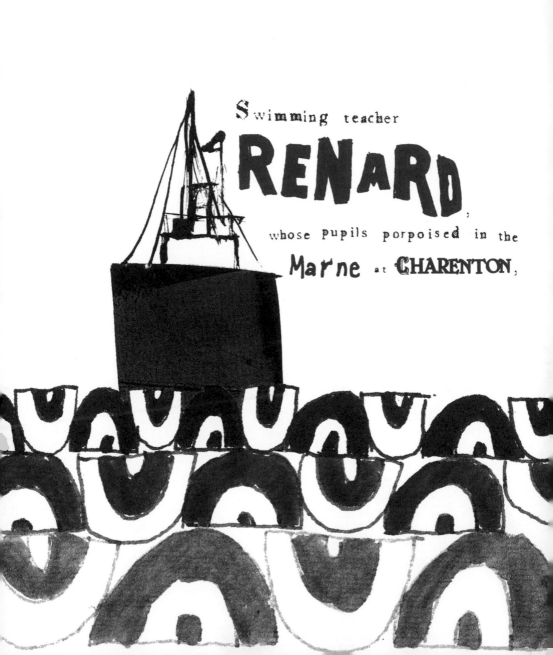

Swimming teacher

RENaRD,

whose pupils porpoised in the
Marne at CHARENTON,

got into the water himself;

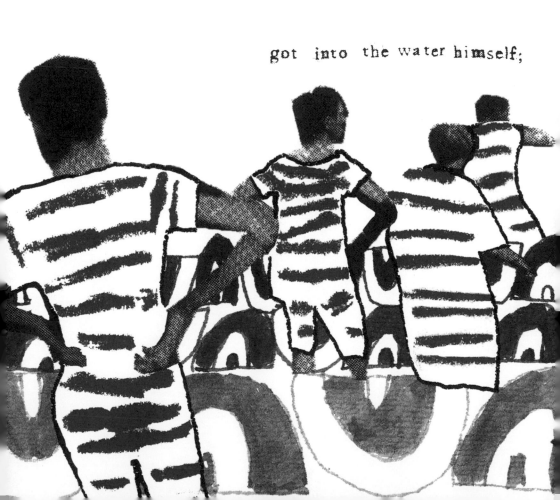

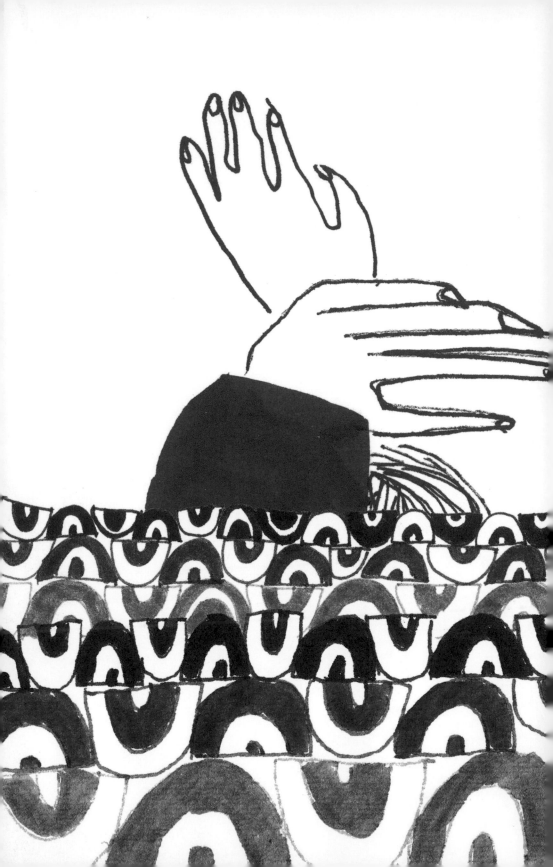

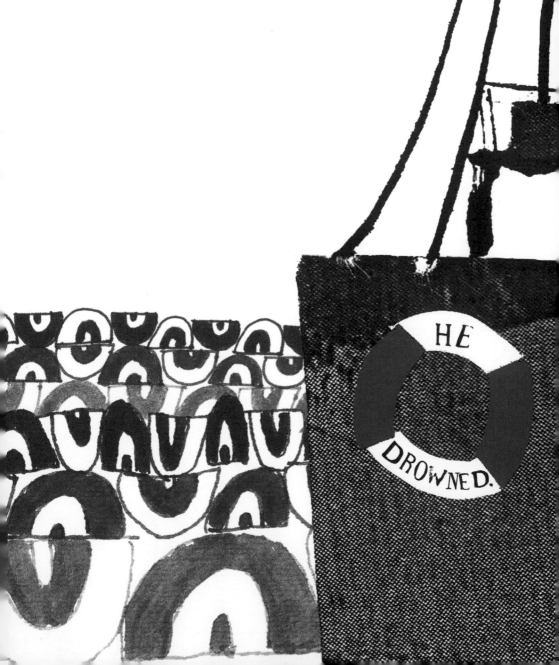

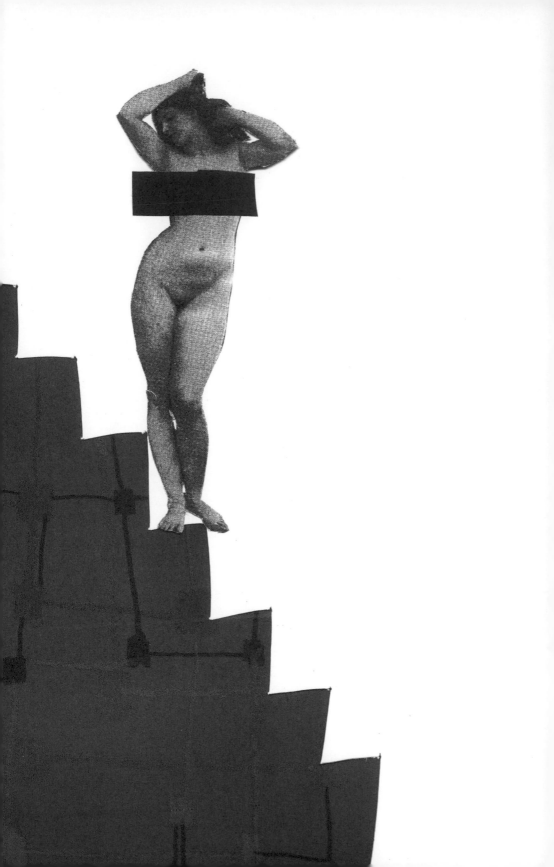

In the evening,

BLANDINE

GUÉRIN,

of VAUCÉ,

SARTHE,

undressed

on the

stairs

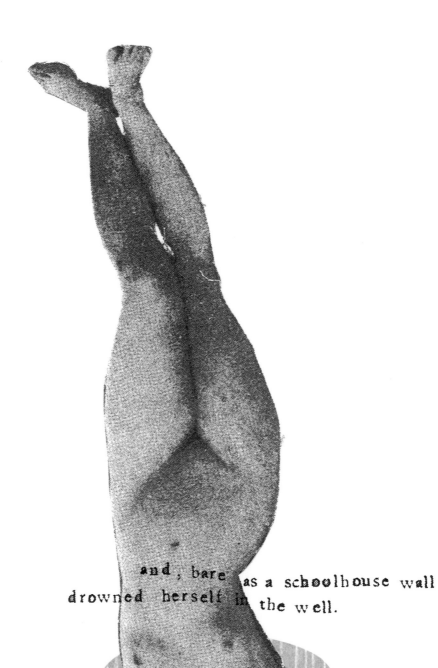

and, bare as a schoolhouse wall
drowned herself in the well.

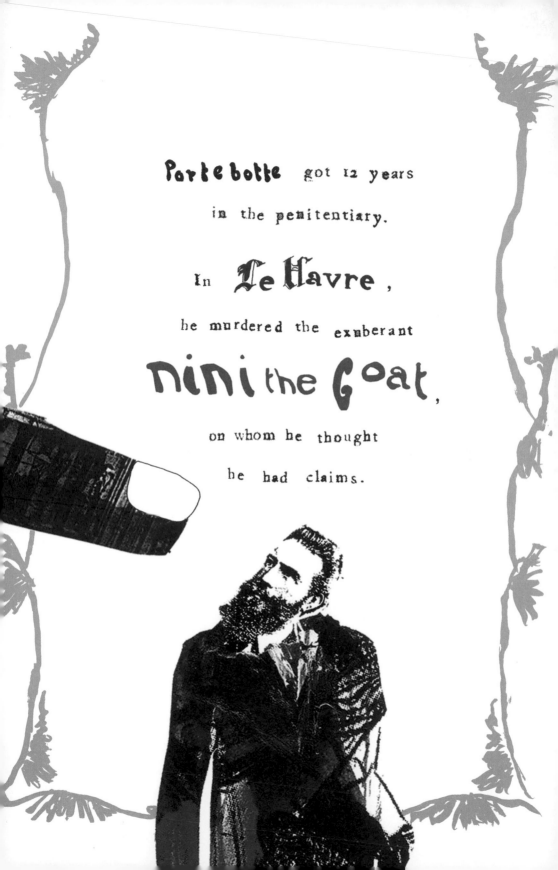

Porte botte got 12 years
in the penitentiary.

In **Le Havre**,

he murdered the exuberant

nini the Goat,

on whom he thought

he had claims.

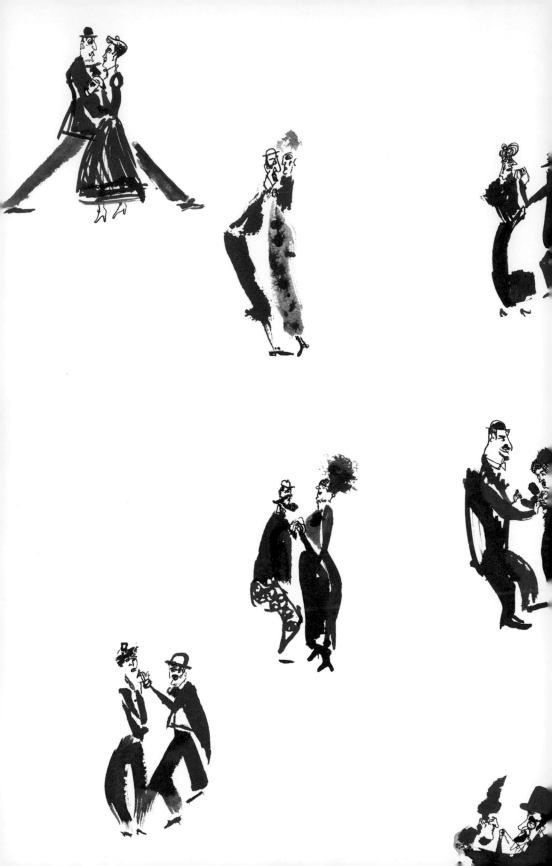

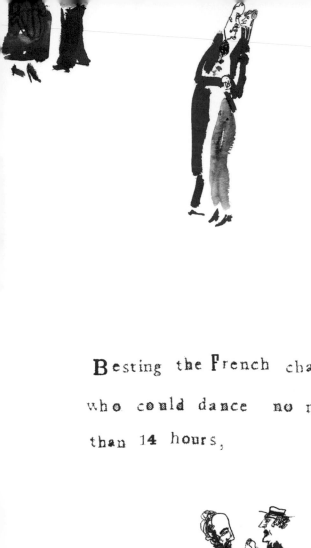

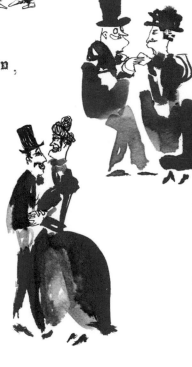

Besting the French champion,

who could dance no more

than 14 hours,

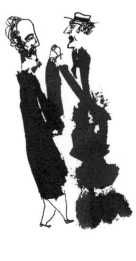

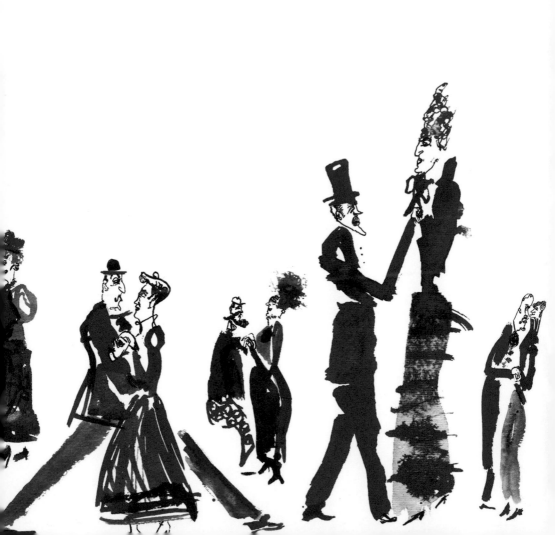

M. GUATTERO

was, at **12:27**, declared winner of the waltz marathon.

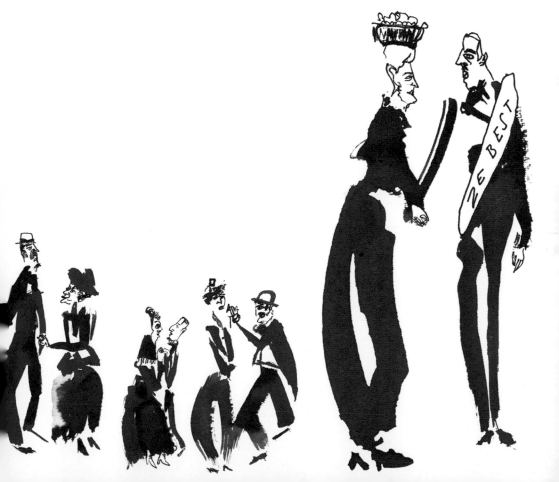

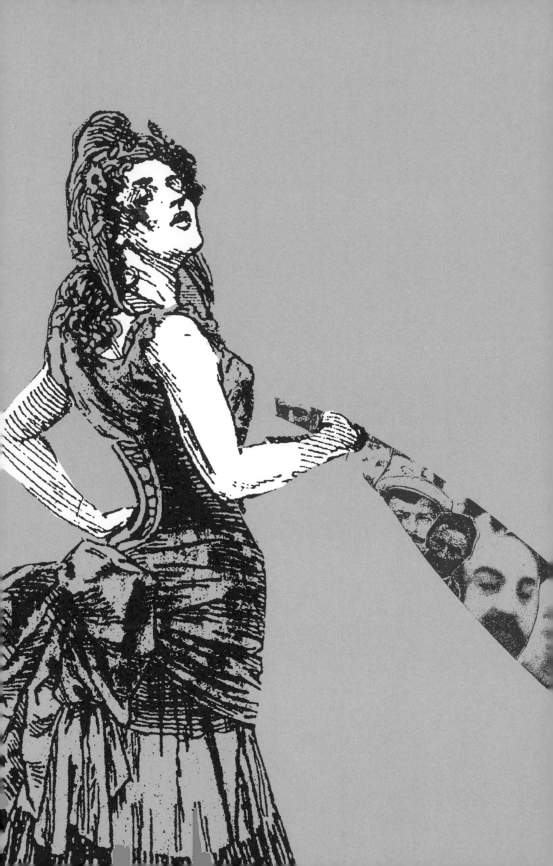

The
 harlots of Brest
were selling illusions
 with the
 additional
 assistance
 of
 opium. At
 several
 houses
 the police
 seized
 gum
 and
 pipes.

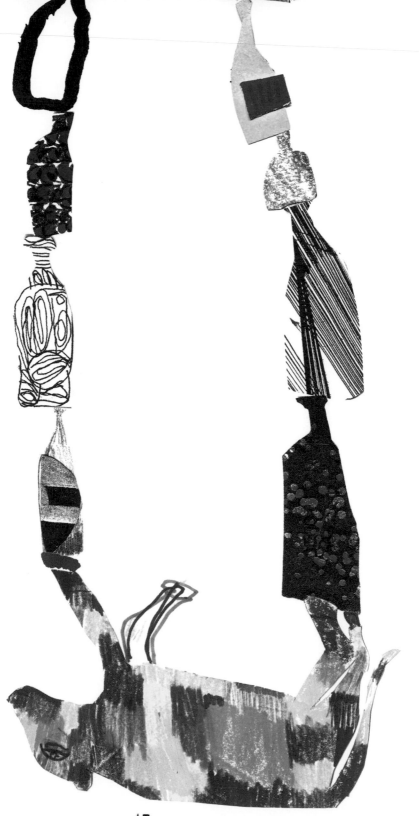

He had bet he could drink **15** absinthes in succession while eating a kilo of beef.

After the ninth, **Théophile Papin** of **IVRY** collapsed.

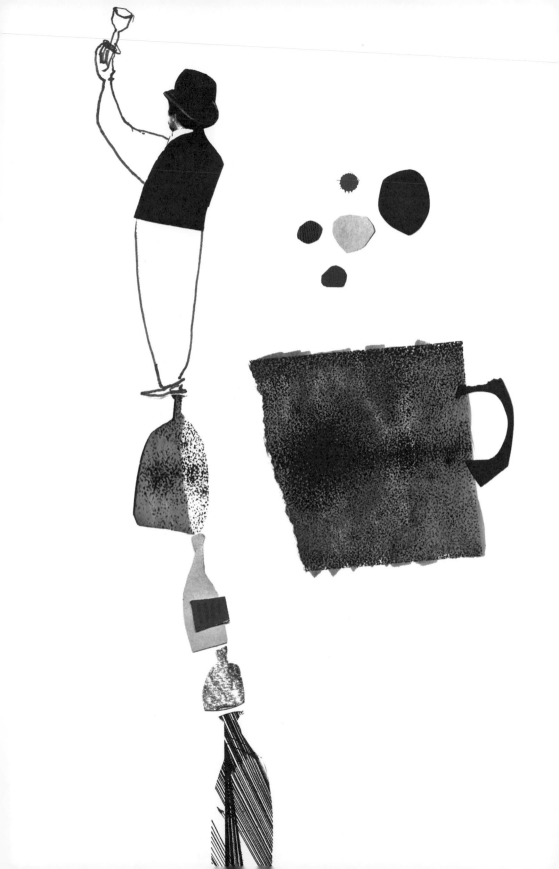

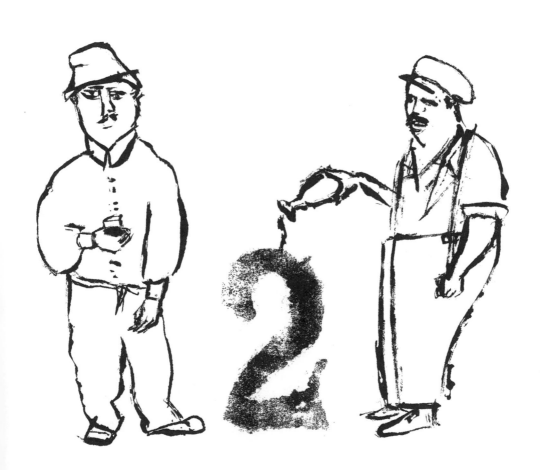

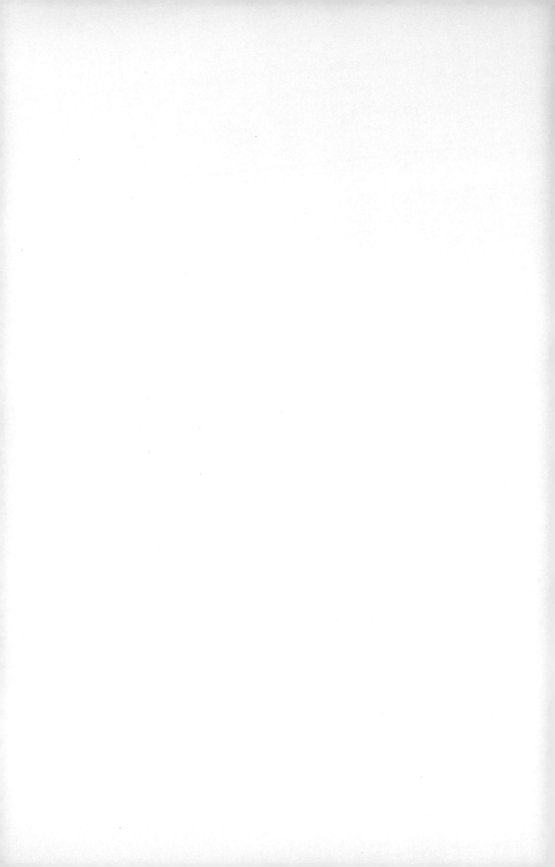

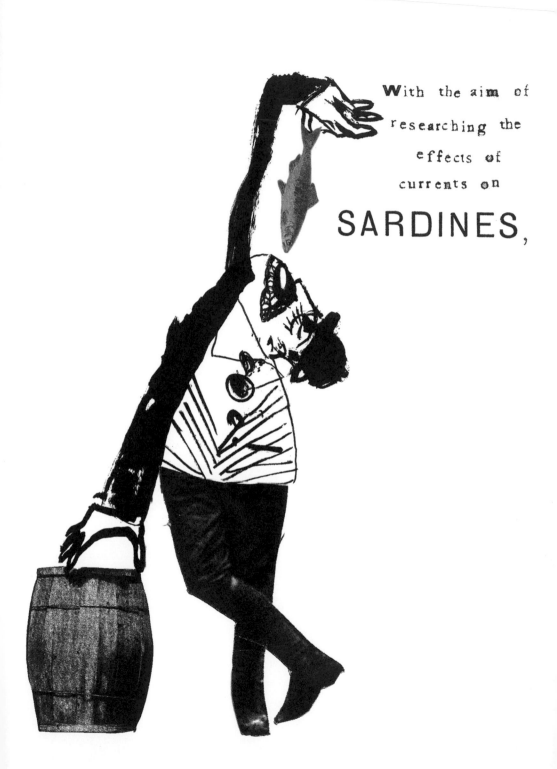

With the aim of
researching the
effects of
currents on

SARDINES,

an oceanographic expedition set out

from BORDEAUX

aboard the ANDRÉE

The sinister prowler
seen by the mechanic

CIQUEL

near HERBLAY train

station has been

identified:

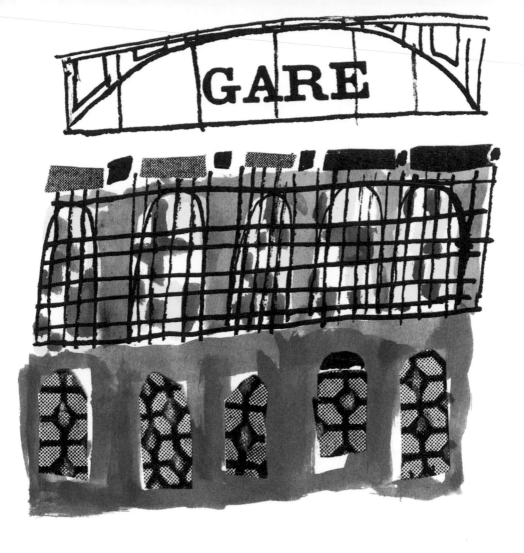

JULES MENARD,
SNAIL COLLECTOR.

For having thrown
a few stones
at the police,

three pious ladies of

Nérissart

have been fined

by the judges in

D OULLENS .

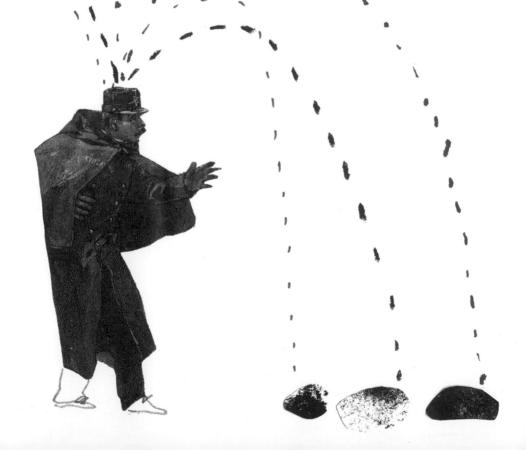

The delegates of the
International Commercial Association
of London were greeted warmly in Lyon.

L'ŒUVRE

À CE SPECTACLE

There were banquets, speeches, toasts.

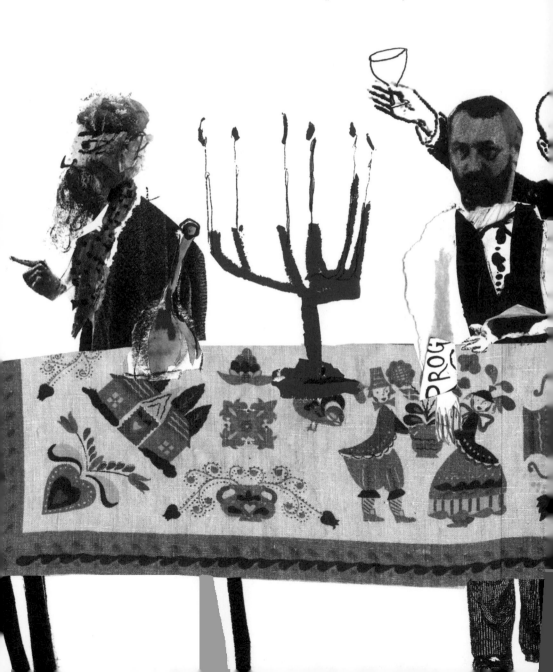

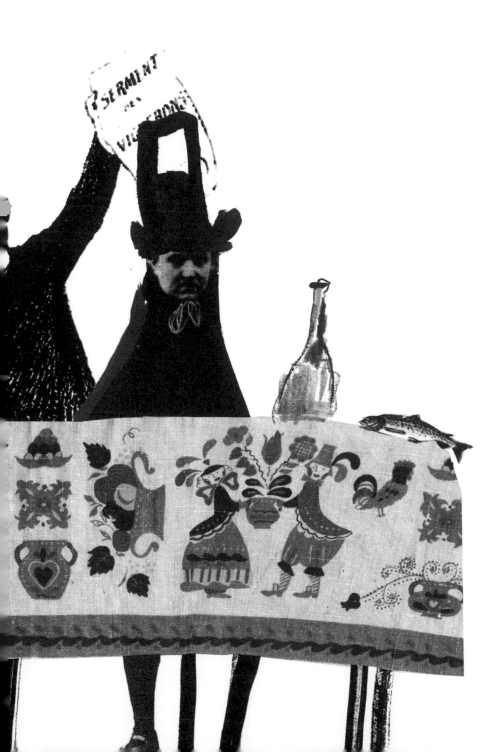

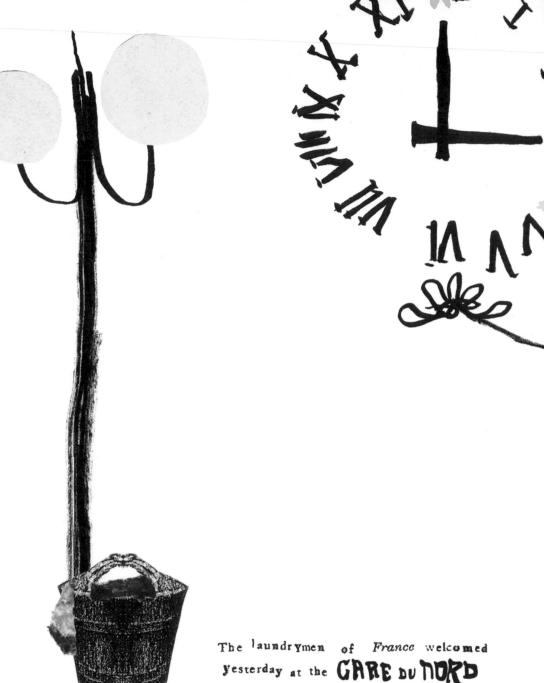

The laundrymen of France welcomed
yesterday at the **GARE DU NORD**
the illustrious laundrymen of LONDON.

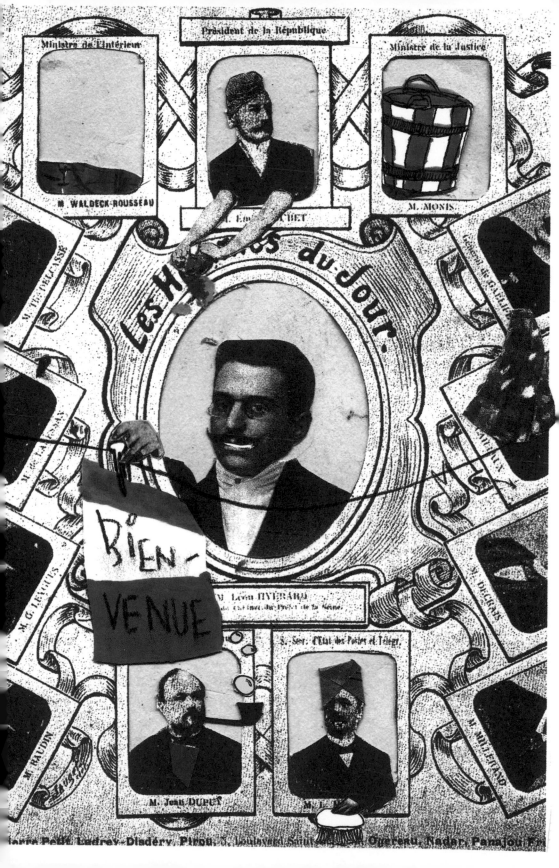

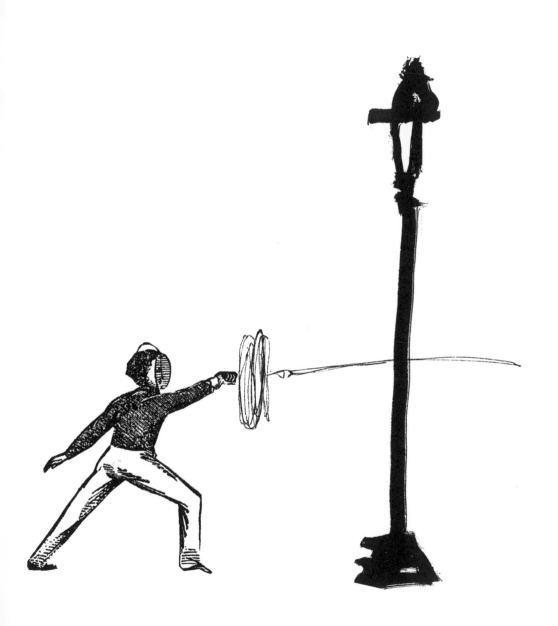

In Saint - cyr, Georges Mahler

was fencing with his knife against a lamppost.

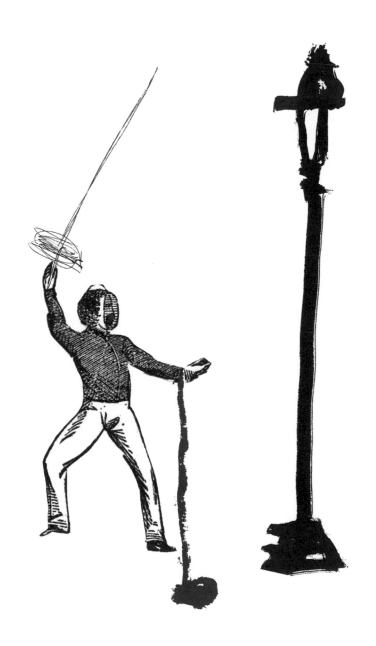

All he managed to do was cut the
artery in his right wrist,

NIGHt.

Of five persons
traveling from DAMVIX
to ARCAIS

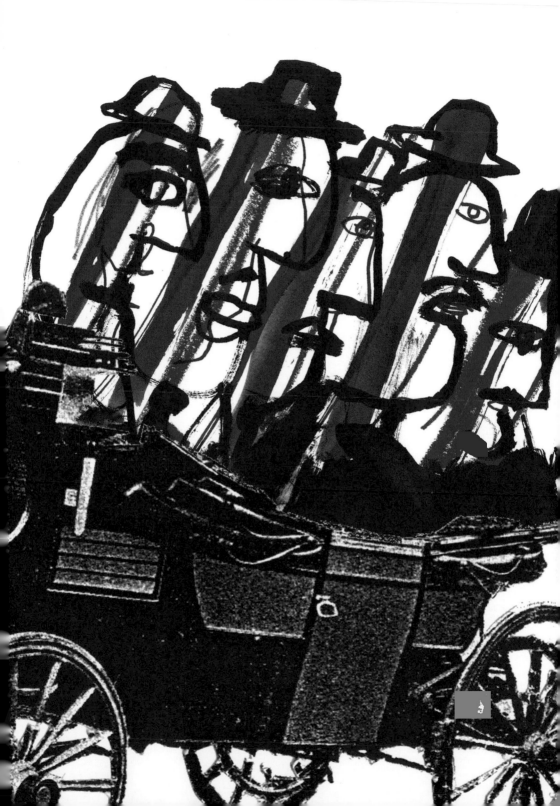

three and the horse were
 drowned

the party having fallen

into the

River Sèvres.

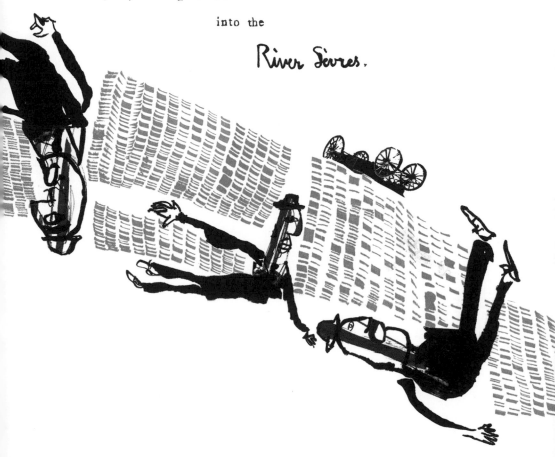

Near COUhé, VIENNe
M BLANC's automobile
knocked over a bicycle.

the cyclist

M. LEBLANC

was picked up in a lamentable state.

To ensure his place in heaven,

Desjeunes of PLANFANG had covered with

Holy PICTURES
the bed where he killed
himself with RUM.

3

« **I'm** telegraphing *Ravachol !* »

cried of
NINI COLONNE Pantin

She was committed for insanity,
the comrade's death being
somewhat notorious.

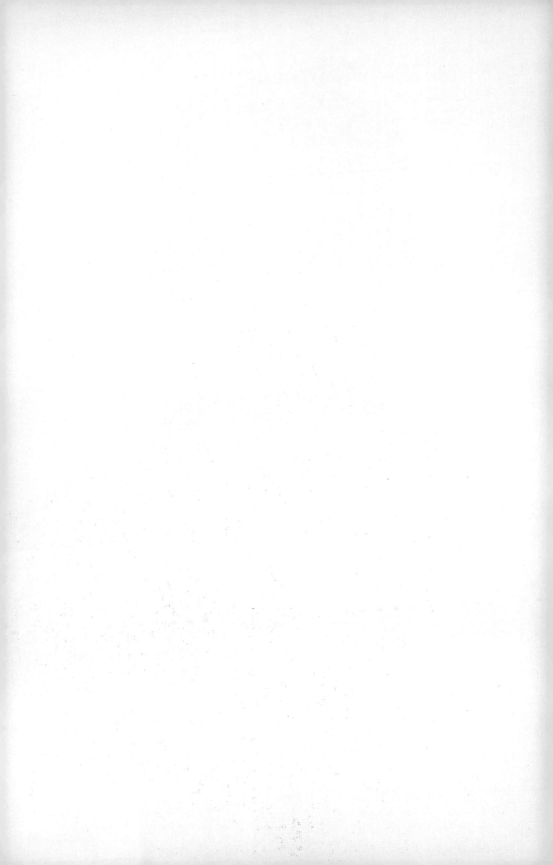

Accountant August Bailly, of Boulougne,

fractured his skull when he fell

from a flying trapeze.

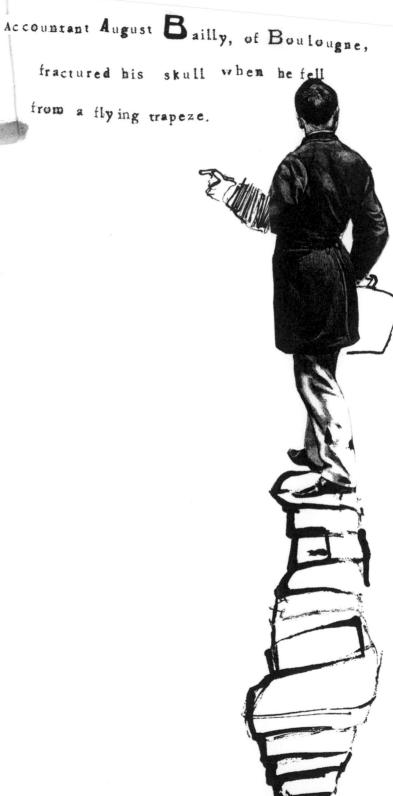

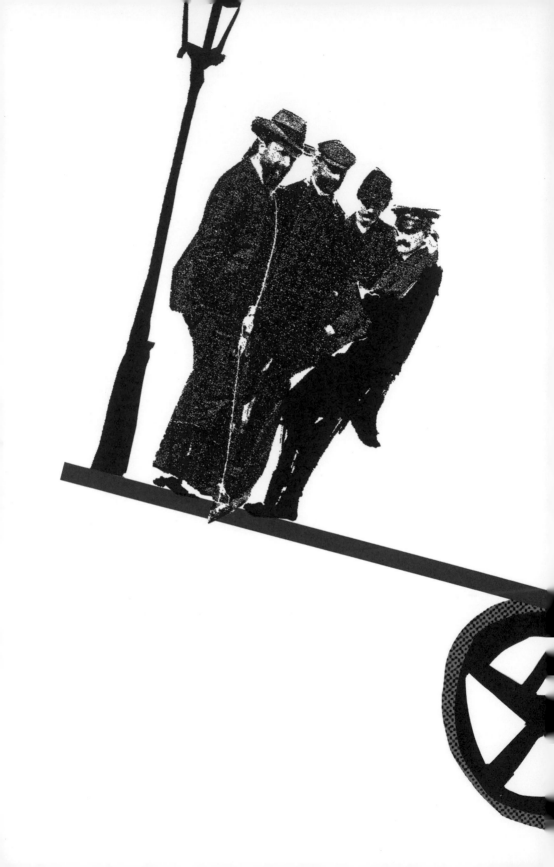

Hanging
onto
the
door,
a
traveler
a
tad
overweight

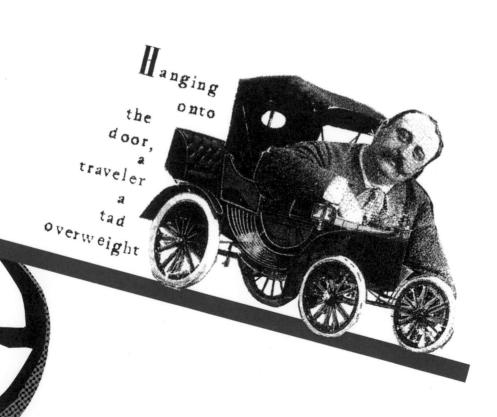

caused his carriage to topple,

in **MÉNILMONTANT**,

and fractured his skull.

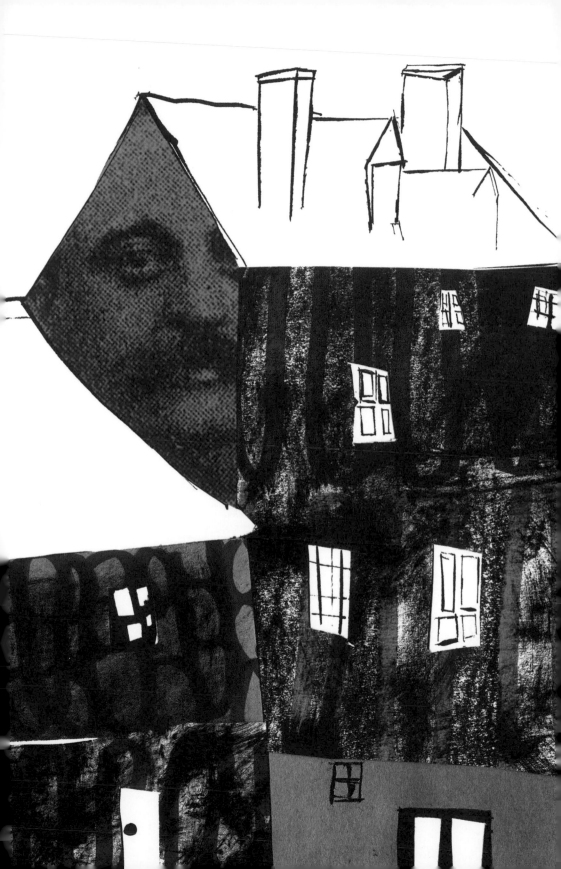

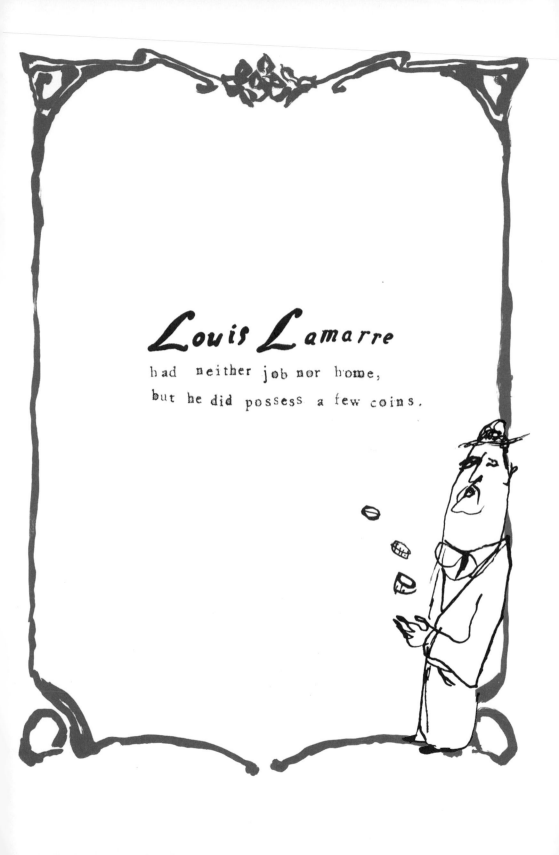

Louis Lamarre

had neither job nor home,
but he did possess a few coins.

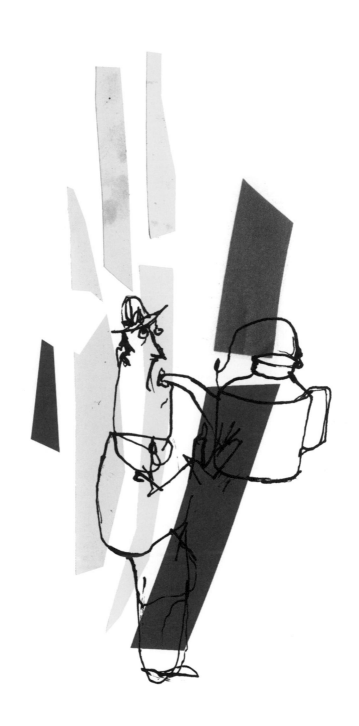

At a grocery in Saint-Denis, he bought a liter of kerosene and drank it.

It was impossible to break into the safe belonging to the horticulturist **Poitevin**, of **Camart**.

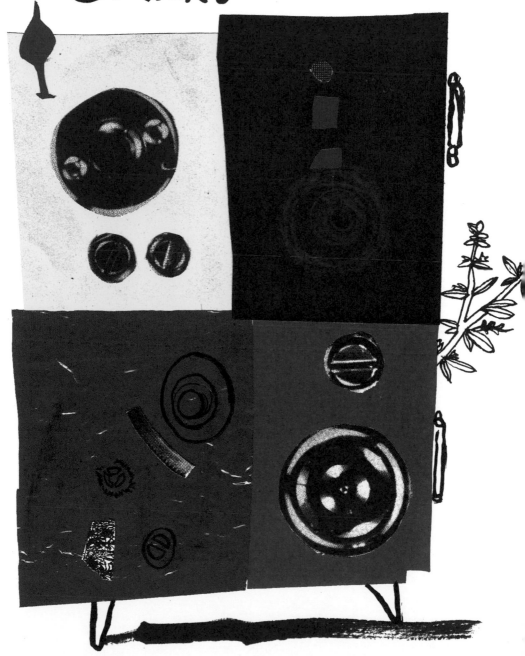

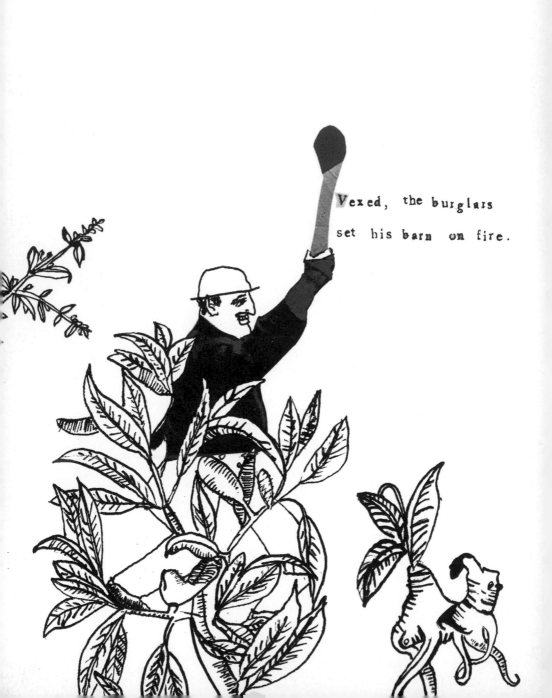

Vexed, the burglars
set his barn on fire.

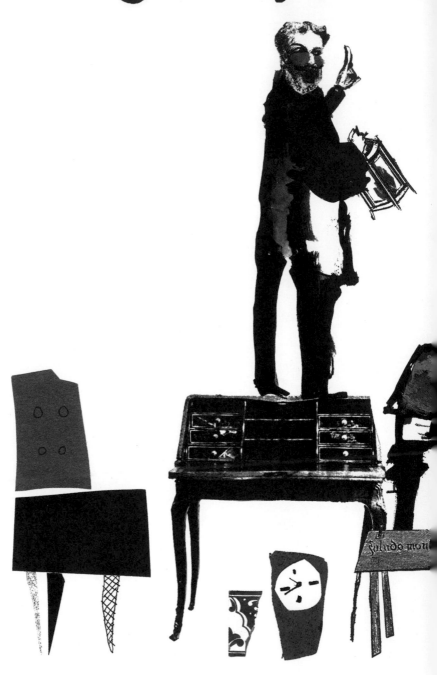

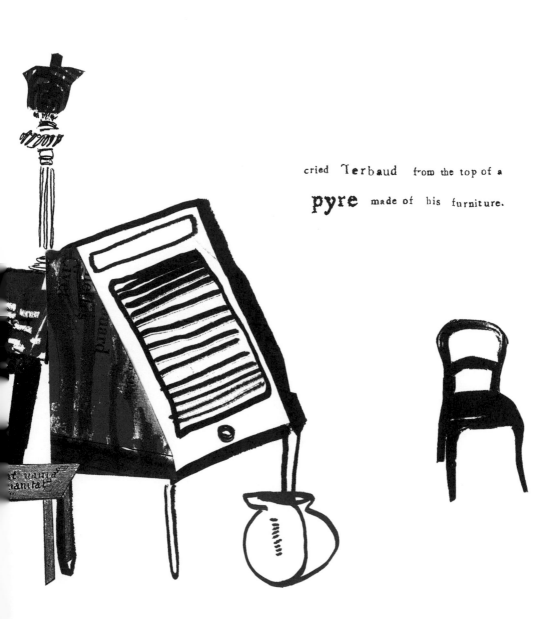

cried Terbaud from the top of a **pyre** made of his furniture.

The firemen of Saint-Ouen
stifled his ambition.

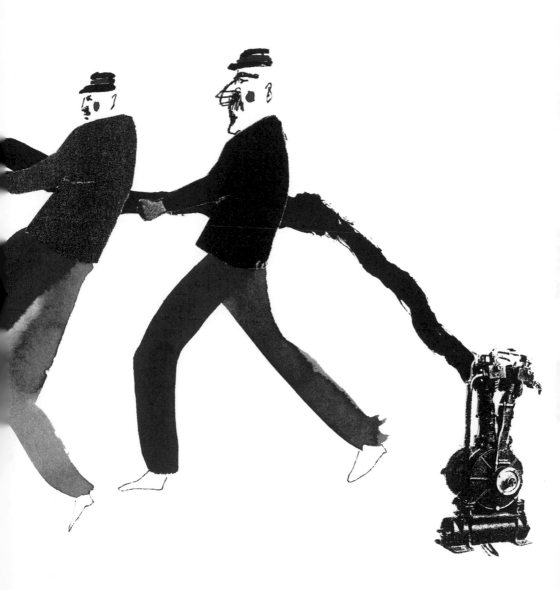

Having just sniffed a pinch of snuff,

A. CHEVREL

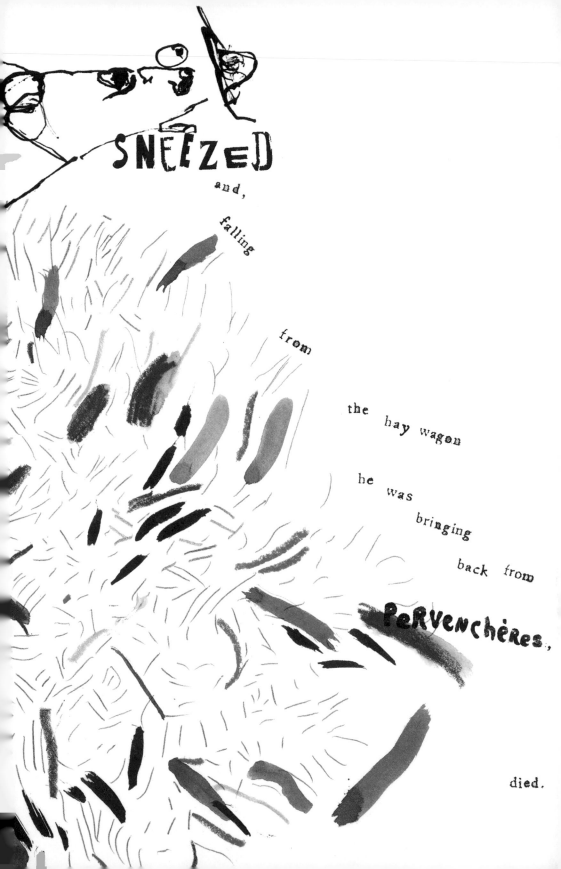

SNEEZED

and,

falling

from

the hay wagon

he was

bringing

back from

PeRVenchères,

died.

The corpse of the sixtyish *Dorlay* hung from a tree in *Arcueil* with a sign reading

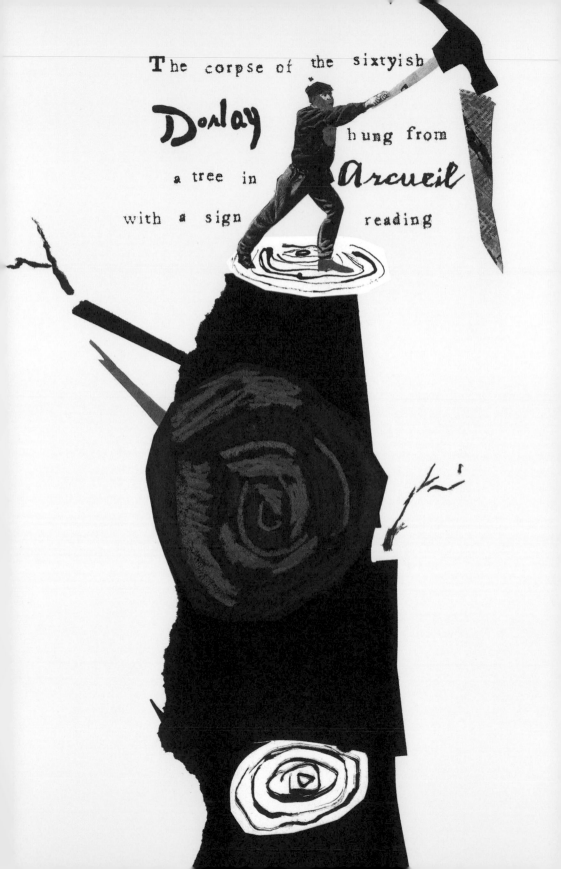

too old
TO
WORK.

Again and again

MADAME
COUDERC

f SAINT - OUEN

was prevented from

hanging herself from

her
win
dow
bolt.

Exasperated, she fled across the fields.

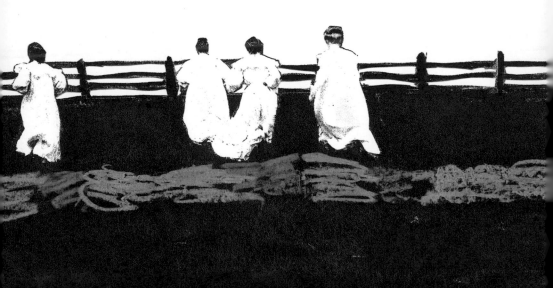

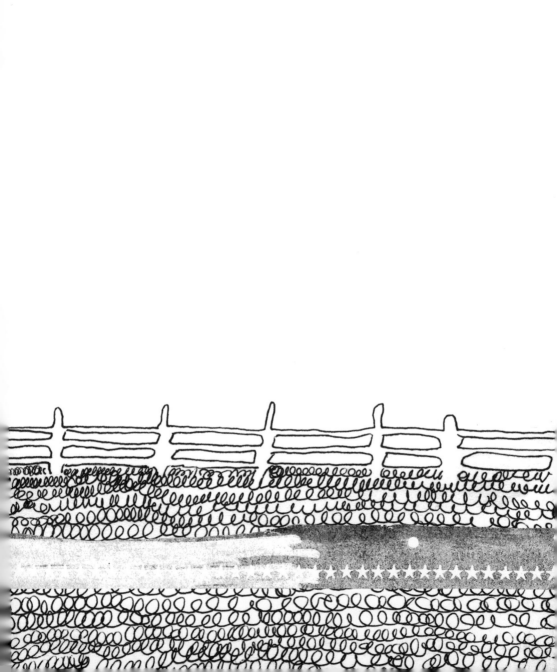

Fin

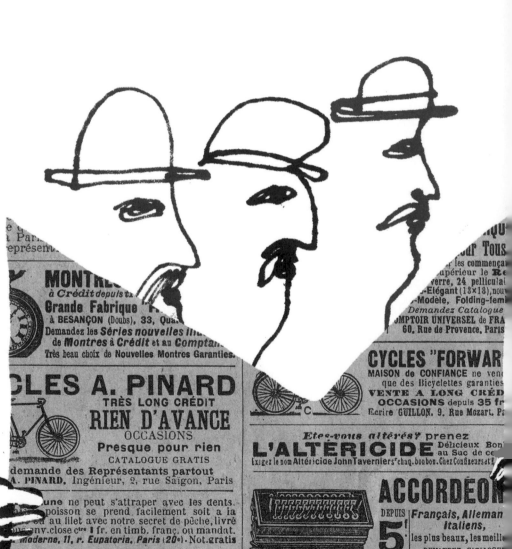

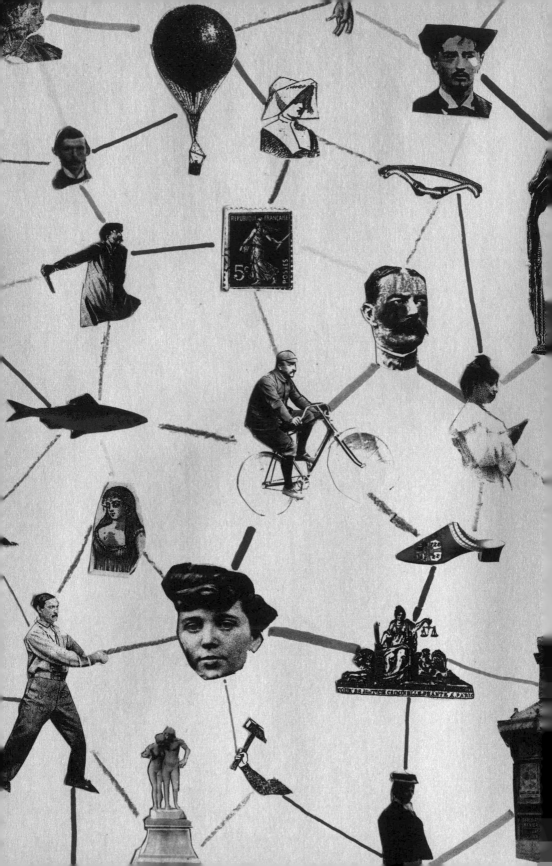